D1348881

SENATVSPOPVLVSQVEROMANVS
IMPCAESARIDIVINERVAEFNERVAE
TRAIANOAVGGERMDACICOPONTIF
MAXIMOTRIBPOTXVIIIMPVICOSVIPP
ADDECLARANDVMQVANTAEALTITVDINIS
MONSETLOCVSTANÆ IBVSSITEGESTVS

LETTERING
FOR BRUSH AND PEN

by A. F. Stuart & Quentin Crisp

FREDERICK WARNE & CO. LTD
London and New York

Authors' Note

The object of this book is to present a series of
alphabets of practical value to both craftsman
and amateur, rather than to deal with lettering
in general terms. The examples have therefore
been chosen with care to give a representative
view of the wide variety of styles available
today.

It is hoped that the student will find a suitable
alphabet for whatever purpose he has in mind,
from a modern poster to an illuminated address,
and explanatory notes have been added where-
ever any difficulty is likely to occur.

In spite of the ready availability of Letraset
and similar forms of instant lettering, we feel
that there is still room for a small practical
handbook viewing the subject from a craft
aspect.

CASED EDITION ISBN 0 7232 1880 3
LIMP EDITION ISBN 0 7232 1961 3

First Published 1939
Second Edition 1949
Third Edition 1969

© Fourth Edition 1976
FREDERICK WARNE & CO. LTD
40 Bedford Square
London

Printed in Great Britain by
Butler & Tanner Ltd, Frome and London

767 - 1075

Contents

Some Useful Suggestions

General proportions of capitals The Roman alphabet is roughly divisible into four groups, as follows:

 1 Width approximately half (or less) of height: E F I J L P S.

 2 Greatest width approximately three-quarters of height: B R X Y.

 3 Square (or slightly less, and with W slightly more, if necessary): A H K M N T U V W Z.

 4 Nearly circular, and circular: C D G, O Q.

No finality can be claimed for these suggestions, and having once mastered the general proportions, one should aim at getting the rhythm of the style being used, rather than geometrical precision.

A note on circular and pointed letters It is often advisable, especially at the beginning of a word, to extend the curves of the circular letters very slightly above the general lettering level. This prevents these letters appearing stunted in comparison with the rest. Similarly, with the pointed styles of the letters A M N V W, the points may extend above or below the line as the case may be.

Important strokes There are a number of letters in the alphabet having strokes which are very important from the point of view of legibility. For instance, there are several pairs of letters in which one letter is only distinguished from the other by some slight addition. R is P with a tail added, while C and G, F and E, O and Q, i and r, n and h, v and y are of a similar nature. The cross-bar of t and the top curve of f are also of like importance.

4

Now as these additional strokes are so necessary, they should never appear insignificant. If they have to be made small, due attention must be given to their weight or serifs.

Lower case letters and legibility The height of the lower case letters may generally be three-fifths of that of the corresponding capitals.

If the capitals are made too large, they tend to have rather an overwhelming effect, and when it is also realised that one reads from side to side, it is obvious that any large upright mass interrupting the movement of the eye must affect the legibility.

In such a style as Italic, where the letters have a naturally elongated appearance, it is sometimes desirable to extend the endings of the tall lower case letters, but the capitals need not, on that account, be increased in size.

A group of words in lower case is easier to read than the same words in capitals. Lower case letters should be made closely together, with the distance between each word about the width of the letter 'o' of that series.

TR TR FIG.1.
A. STRAIGHT &
B. CONCAVE
STROKES

BDEL FIG.2

Elegance A slight concavity of the straight strokes (or to put it another way, a slight thickening just above and below the serifs) will often be found to give an added elegance to a

5

Some Useful Suggestions

letter, and a freer appearance generally. (See Fig. 1.) Serifs may be treated in a similar fashion. Always remember that lettering is an aspect of art, not a branch of practical geometry.

It will be noticed that the lower corners of the letters of Fig. 2 are rounded off. This tends to give their bases a more solid effect.

Serifs Although no doubt originally intended as a natural finish to the brush-stroke, serifs are definite aids to legibility, as they tend to join the letters of a word together and give it a compact and unified appearance, rather than that of a disjointed group of letters. This is particularly noticeable when the words are many and small, but in instances where the effect is rather to 'hit the eye', it need not be overstressed.

The spacing of letters See page 30.

LETTERING FOR BRUSH AND PEN

Part 1: Traditional Forms

Classic Roman lettering, the basis of our modern alphabet, was described by Professor Lethaby as 'the most perfect thing in the art of the Romans'. Simple, dignified, and essentially legible, it forms an ideal introduction to the study of good lettering.

The alphabet produced overleaf is adapted from the stone inscription on the Trajan Column in Rome (*circa* AD 114) and may be used wherever a formal and dignified effect is desired.

With regard to the capitals, the following points may be noted:

1 Width of thick strokes is about one-tenth of the general height.

2 Thin strokes are roughly half of width of thick strokes.

3 The serifs are rather small.

4 The outside edge of O is a perfect circle.

5 The central cross strokes of B E F H rest above the half-way line, and in A and R are below.

6 The following strokes are half-way: arm of G; arm-junction of K; bow of P (which is not joined to stem); crossings of W X and Y.

7

ABCDEFGH
IJKLMNOP
QRSTUVW
XYZ&Æ

7 There is very little difference in thickness of strokes of N.

8 S leans forward very slightly (this need not be too strictly observed).

9 The curves of the letters C D O Q (shown upright in the present alphabet) are slightly tilted to the left in the originals, the use of either style being optional. (See the 'One-Stroke' Roman on page 12 for tilted examples.)

10 As the letters H J K U W Y Z do not appear on the Trajan inscription, the forms shown are modern suggestions.

abcdefghijklm
nopqrstuvw
xyzæ

Contact with general level

g

Curve starts here

h

(also with b d m n p q u)

1234567890

Lower case, or small letters are, of course, merely very distorted capitals, and have reached their present form by a gradual process of development. The transition between capitals and lower case can still be seen in many of the letters of the Irish national alphabet.

Those given here are designed for use with the 'Trajan' Letters opposite. They are three-fifths of the general height of the capitals, and are not treated quite so heavily. The upright strokes of b d, etc. are as high as the capitals, while the tails of the letters p q and y are a similar distance below.

All the top serifs (with the exception of the arm of k, and those on q v w x and y) have a slight upward tilt.

9

ABCDEFGH IJKLMNOP QRSTUVW XYZ&UÆ

The Modern Roman letters shown here have the same general proportions as those of the Trajan Column and are designed as straightforward letters that may be used for all general purposes. Points to be noted:

1 The thick strokes are approximately one-sixth of the general lettering height.

2 The serifs are fairly large and gradually merge into the strokes. They should be treated as growths rather than as appendages.

3 The leg of R is straight, being similar to that of K.

4 Added emphasis is given to the cross-bar of T by the inclusion of serifs above and below the strokes.

5 Once past the narrowest point, the curves of the circular letters quickly thicken up, thus making them both stronger and more legible.

abcdefghijklm
nopqrstuvw
xyz æ
1234567890

These Modern Roman lower case letters, like the capitals, are a rationalised form of those shown previously, while retaining the same general characteristics. The following list shows their general proportions (excluding serifs):

f g (upper portion) r s are two-thirds of general height.

h n are slightly *less* than half of tall strokes.

a b c d e p q t u z are half of tall strokes.

k v x y are slightly *more* than half of tall strokes.

o is practically circular.

The general tendency with these letters is towards an apparent equality of size, and h and n are slightly narrower, and k v x y slightly wider than the main group of letters more on this account than any other.

Although two v's interlocked form w, and the letter m is n with an additional stroke, both are slightly compressed to prevent their appearing too bulky.

ABCDEFGH
IJKLMNOP
QRSTUVW
XYZ&&

Angle of
Pen or
Brush

'One-Stroke' Roman capitals are adapted from the Roman alphabet and may be written with a broad-pointed nib, quill-pen, or, for poster-work, with a 'one-stroke' brush, all of which are obtainable from any art supply store.

Each separate stroke is completed with one sweep of the pen. It is important to remember that the pen is always held at the same angle (see diagram), and that there is no definite upward movement, every stroke being drawn either downward or across.

It therefore follows that O and C are each made with two strokes and A D H (excluding serifs) with three, a new stroke commencing either at the thinnest part of the letter or at an angle.

abcdefghijkl
mnopqrstuv
wxyz
Construction of serifs

1234567890

'One-Stroke' Roman lower case letters are constructed on the same general principle as the capitals except that the top stroke of the bow of a, the cross-stroke of e, and the top stroke of the serifs (see diagram) are made with an upward movement of the pen.

When writing, the lower right-hand endings of the letters a c e h i k l m n t u x z, and the cross-bars of f g r may be joined to the next letter.

The thickness (or 'weight') of the lettering may vary, but for normal purposes the width of the nib should be about one-fifth of the general small-letter height.

This alphabet, together with the capitals opposite, is particularly suitable as a 'book-hand' for prose extracts, poems, MS books, etc.

13

ABCDEFG
hIJKLMNO
PQRSTUV
WXYZ& Angle of Pen or Brush

'One-Stroke' Round-Hand capitals are based on the Uncial letters which were in use from the fourth to the eighth century in Europe and were a pen adaptation of the Roman capitals. Uncials mark an early stage in the development towards lower case or small letters, D H L having ascending, and P and Q descending strokes.

For the above alphabet the pen is held almost at right-angles to the writing lines. It may be held square to them if desired, but the disadvantages of this are the difficulty of keeping the pen in the same position and the insignificance it gives to horizontal strokes such as the top of T and the cross-bars of A E F.

'Oblique' nibs can be purchased for this type of writing. The nib-point is not cut off square, but falls off obliquely to the right, by which means the pen-holder may be held in a slanted

abcdefghijk
lmnopqrst
uvwxyz œ
1234567890

position, while the nib-point is practically horizontal. (See diagram above.)

Round-Hand lower case are similar to the Roman 'one-stroke' letters regarding serifs and general construction.

Where possible, a more cursive type of letter than the normal Roman shape has been given in the above alphabet, in keeping with the rounded effect of the style. This effect is in some measure due to the almost straight handling of the pen (see opposite), as, generally speaking, the more slantingly the pen is held, the narrower become the letters.

This alphabet, with the capitals opposite, may be used as a 'book-hand' for prose extracts, MS books, poems, etc.

A B C D E F
G H I J K L
M N O P Q R
S T U V W X
Y Z Æ &

Caslon Old Face Within a century of the introduction of printing into Europe in 1456, type design, particularly in Italy, had reached a very high level, and from the middle of the sixteenth until the end of the seventeenth century these early (old-face) designs, slightly modified, formed the basis of all printing.

With the beginning of the eighteenth century came the development of the 'modern-face' letter in France, with its heavy thick strokes, slender thin strokes and serifs, and narrow appearance generally.

a b c d e f g h
i j k l m n o p
q r s t u v w
x y z æ
1 2 3 4 5 6 7 8 9 0

Despite these changes, however, when Willian Caslon (1692–1766) began business as a type-founder he used the Dutch 'old-face' designs as models (themselves based on the earlier Italian letters) and produced in 1726 the alphabet shown above. Popular in his day, forgotten during the 'modern-face' vogue, and then revived in the mid-nineteenth century, they are an admirably designed group of letters, legible and unobtrusive, and may be used with advantage on work suggesting tradition or dignity.

Gill Sanserif

A B C D E F G H I J K L M N O P Q R S T U V W X Y Z Æ &

Gill Sanserif Sanserif lettering has become increasingly popular in recent years and there are many varying type-styles such as Univers, Helvetica and Futura available today. The great advantage for the student with regard to Gill Sanserif, however, is that it tends to follow the same general proportions as the normal Roman alphabet, and being devoid of mannerisms or affectation, its forms are easier to follow or adapt as required. The letters O and Q are circular.

The alphabet was designed by sculptor and type designer Eric Gill (1882–1940).

a b c d e f g h
i j k l m n o p
q r s t u v w
x y z
1234567890

Gill Sanserif lower case It will be noticed that the strokes of the lower case letters are not all of a uniform thickness, although the general block-letter appearance is unaffected.

These differences occur at the enclosed portions of a and e, the arm junctions of h m n r u, and the centre portions of g and s, the strokes at these points being slightly narrower than the usual thickness.

The general lettering height is two-thirds of that of the capitals.

ABCDEFGHI JKLMNOPQ RSTUVWX YZ &&YÆ

Italic, an informal variant of the Roman letters, was perfected as a style in the early sixteenth century in Italy. Its chief characteristic is compactness with economy of space, rather than slope, a matter of secondary importance due to its having been originally a pen-hand written with a fair amount of speed.

The capitals (as with those shown here) need only be compressed very slightly, and in some Italic styles they are practically normal Roman, being noticeably less sloped than the corresponding small letters. It was not until about 1540 that any marked slope was given to the capitals; prior to that date they were invariably upright and rather on the small side.

The letters shown above deviate from the perpendicular by $\frac{1}{12}$ in 1.

abcdefghijklm
nopqrstuvwxyz
ægkǫrvwy
1234567890

Italic lower case bears a certain resemblance to normal handwriting.

The flattened appearance given to the top left and lower right-hand sections of the curved letters a b c d e g o p q is due to the inner curves being less sloped than the outside ones, which effect is also continued in the letters h m n r u by joining the curved strokes to the stems at an acute angle.

Notice the pronounced slope to all the serifs, the only exceptions being the tails of p and q. This slope can however be made less pronounced if desired, providing it is made consistent throughout.

The ascending and descending strokes may be extended and flourished if desired. (See page 25.)

ABCDEFG
HIJKLMN
OPQRSTU
VWXYZ&

'One-Stroke' Italic capitals To obtain Italic capitals for normal purposes, it is merely necessary to give a slight slope to the 'One-Stroke' Roman shown previously.

To prevent duplication, therefore, an ornamental type of Italic is given above, the flourishing being a continuation or a slight distortion of the normal pen form. These letters are primarily intended as initials to be used with the lower case opposite. They are constructed on the same principles as the other 'One-Stroke' styles in this book, i.e. the pen is held at a set angle and all strokes are made either downward or across. (See page 12.)

abcdefghijklm
nopqrstuvwxy
z æ g k q r v w y Angle of Pen or Brush
1234567890

'One-Stroke' Italic lower case is the most informal of the pen-hands in this book. It may, with practice, be written very speedily, as the bodies of the letters are extremely simple and as a slight slope is a natural characteristic with the handwriting of most people. The effort to keep the letters at a particular angle is therefore reduced to a minimum.

The letters may be packed very closely when writing, and any free ends to the lower right-hand corners should be joined to the next letter. (See page 13.)

Besides general purposes, this alphabet may be used independently, or with the 'One-Stroke' Roman, for prose extracts, mottoes, MS books, etc.

ABCDEEFG
HIJKLMN
OPQRSTU
VWXYZ&

Flourished capitals Although these letters may be con-
sidered complete in themselves, they are also intended to show
which strokes are capable of extension and where distortion is
possible. For instance, it may be necessary to shorten the
extensions of W or N; A might be preferred minus the top
flourish, or P with a tail similar to F.

Flourishing should always appear as a natural continuation
of the normal strokes, and should never look forced or overdone.

The tails of K Q and R may be extended in formal lettering
if necessary, but the majority of these letters should be con-
sidered as initials, or capitals in conjunction with lower case
Italic, and a group of words composed entirely of them is not
advisable unless a definitely ornamental effect is desired.

a e m r t w
b d b d h k h l l
f g g p q p q
ff tt

Italic lower case letters are naturally freer than the
Roman type and as these examples show, are capable of a
certain amount of flourishing.

The top line gives examples of strokes being added or ex-
tended as line-finishing to the last letter of a word. (d h n u z
may extend as a and m, and s v x y as w). In the second line are
various types of ascending strokes (which may extend past the
general level of the capitals) and in the third and last lines,
examples of flourishings to tailed and double letters.

These flourishings may be used in conjunction with the
letters illustrated on page 21.

A B C D E F G

H I J K L M N

O P Q R S T U

V W X Y Z & 2

a b c d e f g h i

j k l m n o p q r

s t u v w x y z

1 2 3 4 5 6 7 8 9 0

ABCDEFG
HIJKLMN
OPQRSTU
VWXYZ &

abcdefghijkl
mnopqrstuv
wxyz

These two alphabets, which are both traditional divergent forms of our normal Roman letters, are included here for reference purposes.

27

ABCDEFGH
IJKLMNOP
QRSTUVW
XYZ&ABC

Versal letters, which form one of the roots of illumination, were originally used by the medieval scribes for verse and paragraph initials, chapter headings etc., and were generally in colour.

They are 'built-up' letters: the outlines are made first with a pen (which should be springy and not too finely pointed), and the body of the letter is filled in immediately afterwards. The outlining should be done boldly, and not in a painstaking manner, a certain amount of irregularity being permissible owing to the individual effect of the style.

All straight strokes are slightly concave, while serifs are made

ΛΛBÐЄFG
hкLϬNPR
SͲͲUШXY
1234567890

with a single movement of the pen and added to the stem before 'filling-in'.

Versals, as coloured initials or headings to be used with black text matter, may be either red (vermilion), blue (cobalt or ultramarine) or green (veridian or emerald). These colours are the safest, red being the commonest and most effective.

The last three letters on page 28 show how a small decorative motif can be introduced into the thick strokes.

This page of alternatives shows how the shapes of the letters can also be varied, irrespective of any further decoration. The numerals are modern suggestions.

A B C D E F G
II IO ES OG LI RA TA

H
LETTERS
EQUALLY
SPACED
OILY

LETTERS
SPACED AS
SHOWN
ABOVE
OILY

The spacing of letters is rather an involved subject to deal with in a few lines, owing to the many possible combinations and varying styles of letters. Its object, only reached with practice, is to create a general effect of evenness, and to overcome the either cramped or spread-out effect occurring when the letters are equally spaced (H).

The following simple rules refer to normal lettering, and solve all but the niceties of the subject:

1 The space between two straight strokes (A) should be greater than that between a straight stroke and a curve (B), or two open letters (C).

2 Two curves (D), or a straight and a projecting stroke (E), should be placed closely together.

3 Projecting strokes on the same level may touch if desired (F), or overlap when on different levels (G).

THE ROMAN ALPHABET

lower case letters

Italic 'One-Stroke'

Further examples of spacing will be found in the lettering of the title page and frontispiece of this book.

30

Part 2: Modern Forms

Introduction

The general tendency with most modern lettering is not merely to create new typefaces but to increase the significance of the Roman characters by certain exaggerations of their proportions. Any departure from the Roman forms involves a decrease of legibility, but since lettering for display is used chiefly for the writing of names it is not enough that it should be readable. The word 'Smith' written in Roman capitals may convey nothing in particular, but written in Albertus it means something solid with a sense of character; written in Gill Sanserif Bold it means something very practical with a universal appeal; written in an elegant modern script it means something exclusive with an appeal to the eye. So Modern lettering stands poised between the least sacrifice of legibility and the greatest scope of imaginative suggestion.

Its variations are limitless but chiefly they are influenced by the use of drawing instruments towards geometric forms (the circle and the straight line), which can be made with a pair of compasses and a ruling pen. These make for speed in execution and conveniently echo the simplifications adopted by modern decorators and artists.

ABCDEGV HIJMORW QPFKLNS TUXYZ &

Falstaff and Bodoni The simplest variation from the Roman characters that occurs in modern lettering is an increase of the difference between the thick and the thin strokes. This produces types like Falstaff, Bodoni and ultra-Bodoni. As with most eccentric types, the amount of lettering to be read determines the limit of exaggeration possible, but in order to obtain the heaviest mass of type or the greatest area of colour, the capital O can be drawn slightly more than circular—slightly broader than its height—with the two halves divided only by a thin vertical line and all other letters can be made uniform with it, noting that circular letters should be made slightly thicker than squared letters. The thick parts of the strokes of O,

abcdegvhij
morwqpfkl
nstuxyz æ fi
1234567890

for instance, should be thicker than those of H.

In the present alphabet the thick strokes of the capitals are one-third of their height, with the curves made slightly thicker as mentioned previously. Note that the serifs are also fairly long and, in the case of H W h m, may be joined to those of the adjoining strokes. Where thin strokes end in a serif, as in A C E V for example, care should be taken to make these serifs fairly heavy in order to balance the letters and assist in legibility. Two styles of serifs are shown and either may be used as desired. Notice also that the inner lines of the circular letters are straight and only curve off at their ends.

ABCDEGV
HIJMORW
QPFKLNS
TUXYZ &

Broadway type differs from Falstaff and Bodoni by being a sanserif letter and by having only the main stroke thickened. It has therefore slightly less mass than the foregoing letters, but would take up the same amount of space. This might become a disadvantage but it can be condensed, not by cramping each letter, which can make some condensed types unattractive, but by overlapping the letters and 'counterchanging' them—that is to say, by making the thin strokes white where they cross the thick strokes of the preceding or following letter.

Three different styles of thick strokes are shown above and

abcdegvhij

morwqpfkl

nstuxyz œ

1234567890

all these strokes are capable of any amount of further decoration if a more unusual effect is desired by the artist. For instance the gradation of tone made by a series of vertical lines on some of the letters could be done with a hand stipple or with a gradation of colour, and an ingenious letterer might, for writing a single word, continue the thin stroke of a letter as a white line into the adjoining thick stroke. Thus the centre lines of E F could cut into the middle of the down strokes, and the circles that form a b d g could be completed on the down strokes, but this would have to be done with great discretion.

Compacta

A B C D E G V

H I J M O R W

Q P F K L N S

T U X Y Z & &

Compacta is a condensed style where the normal letter curves have been flattened as well as compressed and by this means a certain uniformity of shape has been arrived at. Taking the O as a basic shape, the letters B C D G H J R Q P S U might all be considered to some extent as modifications of it in one form or another and they are all also of a uniform width.

The other letters are designed to fit in with this general pattern, E F L being slightly narrower and K T V X Y a trifle wider than O. Note that X is not a true crossing of two strokes, but is opened out slightly from the centre.

The cross-strokes of B E F H L etc. are slightly lighter than the upright strokes, to avoid heaviness, as are also the centres of the

a b c d e g v h i j

m o r w q f k l

n s t u x y z æ

1 2 3 4 5 6 7 8 9 0

narrow top and bottom curves, where these occur.

Two alternative outline forms of this alphabet are shown, and the outlines and shadows may in each case be made heavier if desired.

The lower case letters follow the same pattern as the capitals, with o giving the standard of proportion for many of the others. In the present example the general lettering height is three-quarters of that of the capitals, while the ascending and descending strokes are of equal size to them.

Note that the same flattening of curves occurs, and this feature also extends to the tails of **g j f y**, which appear as flat cross-strokes.

Rockwell

ABCDEGV

HIJMORW

QPFKLNS

TUXYZ &

Rockwell and similar types, though still formed with rigidly geometric shapes, and without any difference of thickness between one stroke and another, are more varied than block lettering because they have serifs. If these serifs are made very small we have quite a useful typeface, attractive and readable, though for display purposes the serifs can be made longer. They should not be made very bold, as in order to preserve the nature of the type the serifs must be as bold as the main strokes of the letters and if all these strokes were too bold it would lead to confusion.

The outline form of this type shown here is a combination

abcdegvhij
morwqpfln
stuxyz æœ
1234567890

of shadow writing and outline, the under strokes and the right-hand edges being thicker. This thickening can be either subtle or very marked. It would in fact be possible without entirely losing legibility to omit the thin strokes—that is, to draw only the shadow of a white letter cast on a white page. In this way, only using a Gill Sanserif type, the Granby shadow type is formed. All types that have a uniform stroke can, of course, be treated in this way. It should be assumed that the light comes from an oblique angle but not at forty-five degrees from the horizontal as this would leave the diagonal stroke of the upper case N and of the R and K without any shadow at all.

Vogue

A B C C D D E G

G V H I J M O R W

Q P F K L N S S T

U U X Y Y Z &

Vogue type, and types akin to it, gain their greatest distinction from the exaggeration of the difference between the broad and the narrow letters. The E and the L for instance are made much narrower than the H. But this difference in breadth is variable, the U can be wide or narrow. The B and P can be formed with very shallow curves and the S can lean at any angle. The only guide in this matter is the word that has to be written and care should be taken that a whole sequence of narrow letters are not placed together and that unless space demands it the O should always be circular. If the circular

abcdeggvhij

morwqpfkln

sʃɾtuxxyzæ

1234567890

letters must be condensed, it should be done by drawing shallow curves, as shown in the alternative examples of C D and G above. The condensing of the curves of lower case letters would not be advisable, however, and as far as possible the circular appearance of these letters should be retained. Notice that the cross-bars of A G R P are slightly below the centre line, while in B E F H they are slightly above. Ruler and compass are used almost exclusively in the formation of this alphabet to give a modern elegant effect. The alternative version shows the use of a double line to form the general outline.

Albertus

A B C D E F G
H I J K L M N
O P Q R S T U
V W X Y Z &

Albertus is a modern letter style of a distinctive character, designed by Berthold Wolpe. Although at first glance the letters appear quite straightforward, they are in fact extremely subtle in shape and proportion and for this reason the alphabet above has been slightly simplified to assist the student.

It will be noticed that the serifs are small and blunt, giving a wedge-like appearance to many strokes. The cross-bars of E F are especially noticeable in this way and those of T Z continue the same idea. The strut of R is equally distinctive.

Notice the heavy effect to the bases of N W, due to their squared-off base lines. The D is slightly narrower than might be expected, while the central curve endings of B P R are all quite narrow, with those of B coming more or less to a point.

abcdefghijk

lmnopqrstu

vwxyz æ &

1234567890

The curves of C G O Q give a slight suggestion of being tilted to the left, as shown in previous alphabets in this book (pages 12, 20). Note also the additional top stroke to J and the tail to U.

Of the two ampersands illustrated, that on page 42 shows the correct one, while that on page 43 is a simpler alternative.

The lower case letters also have many distinctive features, such as the right angle inside the centre of a, the flat base of b and the top of q, the lighter right-hand curves of e and o. Notice also that the lower curves of a d g p q u and the upper ones of b h m n terminate more or less as points, while the top circle of 8 is slightly lighter than the lower one.

ABCDEFG

HIJKLMN

OPQRSTU

VWXYZÆ

Script Lettering This is much freer than the foregoing alphabets, and is obviously an adaptation of a form of hand-writing. Many types of script lettering are in use today and often give the appearance of being written with speed, especially when emphasising some catchword or phrase in advertisements. With the letters shown above (based on Trafton Script) a certain formality has been observed, but the student can no doubt develop many variations from them. The slope of the letters can be varied for instance, or the thick strokes made

$a\,b\,c\,d\,e\,f\,g\,h\,i\,j\,k\,l$

$m\,n\,o\,p\,q\,r\,s\,t\,u\,v$

$w\,x\,y\,z\,s\,w\,æ\,\&$

$1\,2\,3\,4\,5\,6\,7\,8\,9\,0$

heavier. The tails of G K L R etc., may be extended or flourished as shown on page 24, or the loops to the letters B D P R d p may be deleted if desired. The lower case letters approximate even more noticeably to handwriting; they may be joined together if desired, although this may not always be necessary.

It will be noted that the pen or brush is assumed to be held at a slight angle (see page 23). This causes all curved strokes to appear slightly tilted and also naturally emphasises the cross-strokes of L T Z etc.

SQUARE & CO

OVERLAP LTD

STEELWORK

FABRIC TYPE

SPEED

BABYWEAR

WATERPUMP

SUNLIGHT

Examples of Modern Lettering Whereas the foregoing specimens obtain suggestion or character only generally, these examples of trade names will show that a pictorial quality can be given to lettering that makes it self-explanatory. This is only possible with single words or phrases as the forms made are bound to become elaborate. In actual practice, it would not be necessary to write the word 'speed', for instance, in the way shown opposite as it already has associations of its own, but it might be very advantageous to write the word 'Jones' in this way if it were the name of a manufacturer of cars. There is no limit to the length that this pictorial lettering can be taken by an imaginative letterer, except legibility. These samples merely suggest the possibilities ahead. A strong solid letter of any formation can be treated to any decoration, inlined with a wavy line or with a lightning streak, etc., but it is better to decorate a simple letter than to endeavour to form the letters out of pictorial units. For example it would be better to decorate a bold black letter with a brick pattern in white than to form the letters out of bricks. It avoids any violation of the fundamental principles of lettering.

SURREY COUNTY LIBRARY | JNF

(Headquarters, 140 High Street, Esher)

This book must be returned to the Branch or Travelling Library from which it was borrowed, by the latest date entered above.

Charges will be payable on books kept overdue.

TOKEN SECTION | Please note that reminders will not be sent for books kept overdue. L24